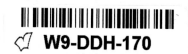
AT THE BALLPARK

Text and Photographs by
Ken Robbins

Viking Kestrel

This book is dedicated to Joseph Salant, a real baseball fan.

VIKING KESTREL
Published by the Penguin Group
Viking Penguin Inc., 40 West 23rd Street, New York, New York 10010, U.S.A.
Penguin Books Ltd, 27 Wrights Lane, London W8 5TZ England
Penguin Books Australia Ltd, Ringwood, Victoria, Australia
Penguin Books Canada Ltd, 2801 John Street, Markham, Ontario, Canada L3R 1B4
Penguin Books (N.Z.) Ltd, 182–190 Wairau Road, Auckland 10, New Zealand

Penguin Books Ltd, Registered Offices: Harmondsworth, Middlesex, England

First published in 1988 by Viking Penguin Inc.
Published simultaneously in Canada
Copyright © Ken Robbins, 1988
All rights reserved

Library of Congress Cataloging-in-Publication Data
Robbins, Ken. At the ball park.
Summary: Hand-tinted photographs and simple text recreate the fun and excitement of a day
at a baseball game.
[1. Baseball—Fiction] I. Title.
PZ7.R5327Daw 1988 [E] 87-34060
ISBN 0-670-81600-0

Color separations by Imago Ltd., Hong Kong
Printed in Hong Kong by Imago Publishing Ltd.
Set in Clarendon Book
1 2 3 4 5 92 91 90 89 88

ACKNOWLEDGMENTS:

The author wishes to thank everyone who helped to make this book
possible, most particularly the players whose skill and dedication
to the game makes it such a pleasure to watch. Thanks are also
due to Doug Kuntz, my occasional but always able assistant and
colleague; to Lou Schwechheimer of the Pawtucket Red Sox orga-
nization, for his unfailing and extensive cooperation; and to Jay
Horwitz of the New York Mets, a man with the grace to realize that
the future of baseball lies with the children whom it beguiles. K.R.

NOTE AND CREDITS:

All photographs in this book were all taken in black and white, and
were hand-colored by the author. The photograph on page 30 was
taken by Steve Berman, and the one on page 20 is by David Tokress,
courtesy of *Newsday.* All others were taken by the author.

Baseball is a special game in America. Everyone has seen it on TV. Nearly everyone has played it. But going out to the ballpark for a real game is something else again. When you walk into the ballpark and get your first glimpse of the green green grass, your heart just has to beat a little faster. When you hear the cheering of the crowd as the home team takes the field, when you feel the thrill of a home run, or the agony of a strikeout, you share the excitement with thousands of people, and you're part of the very game itself. Watch the players do their slow dance. Watch the umpire make his calls. Eat a hot dog. Give a cheer. And get to the ballpark early. You'll see things you never saw on TV.

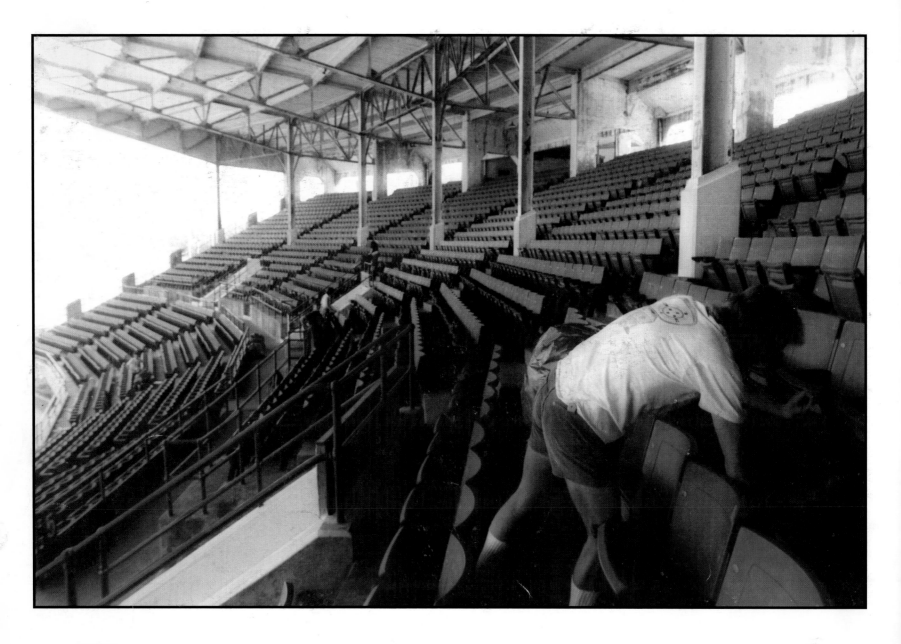

The stadium crew goes to work early. The stands are cleaned.

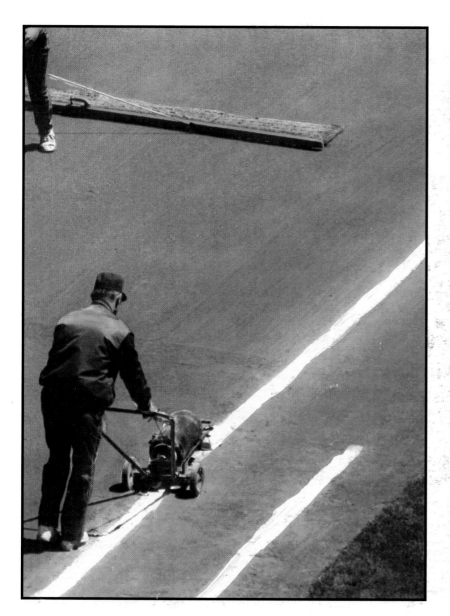

Fresh baselines are painted. The bases get a fresh coat of paint,

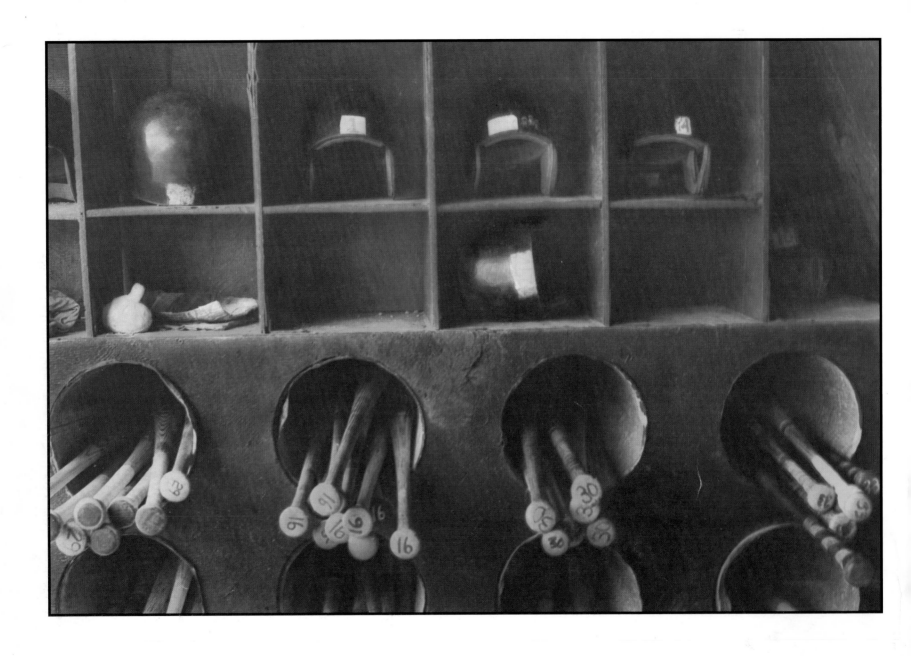

and the bats are put out for the game.

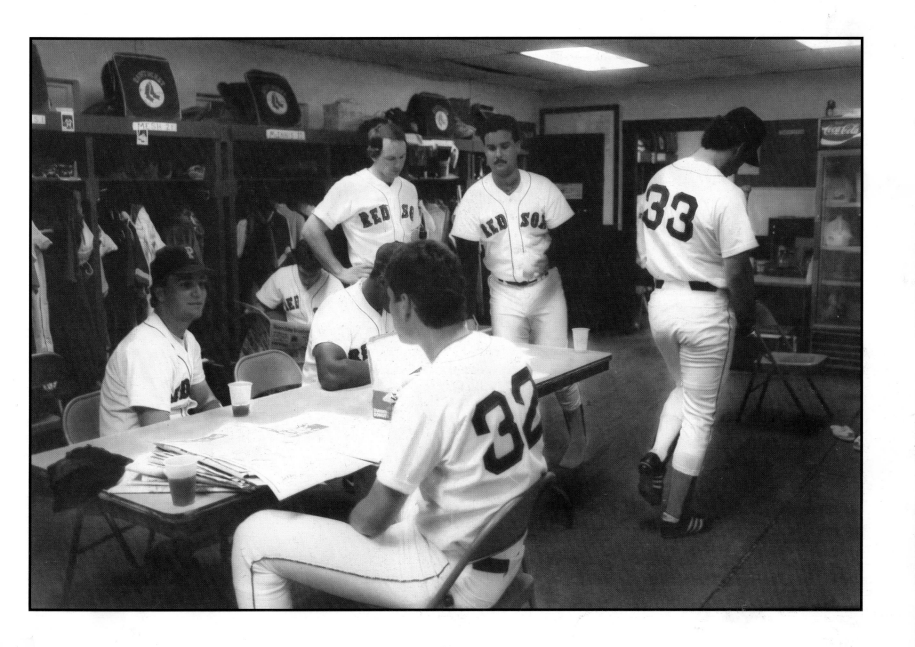

By now the players have arrived, and they suit up in the locker room.

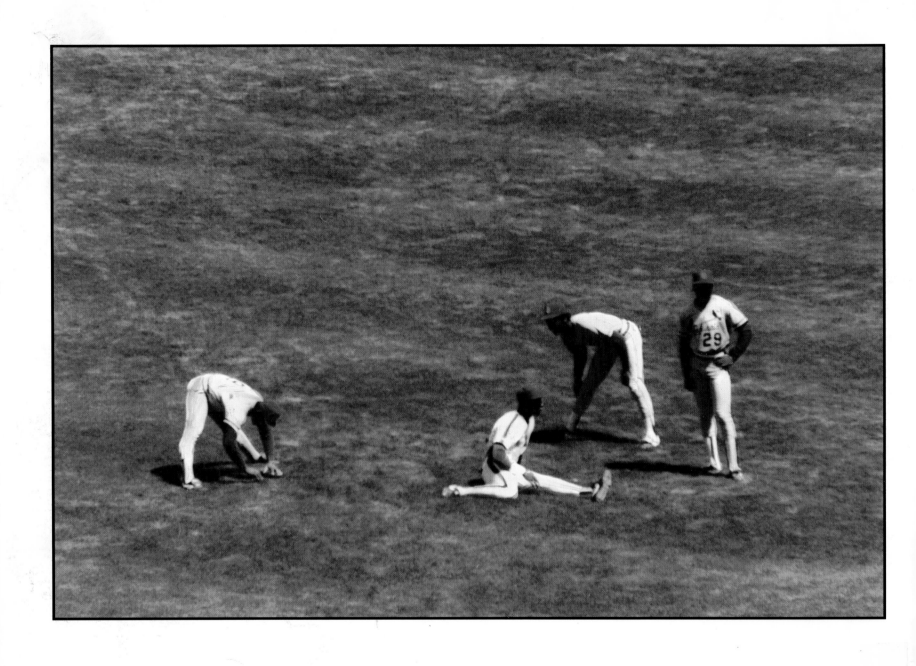

Then it's out on the field for exercises

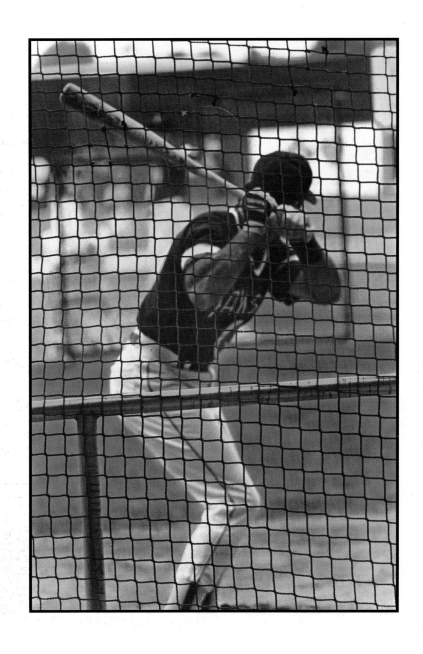

and batting practice.

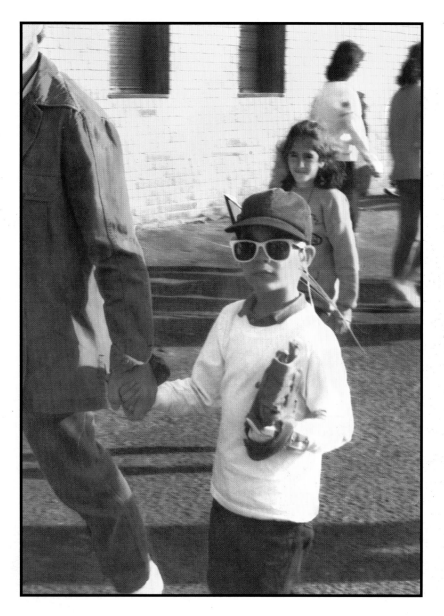

Now the fans are arriving.

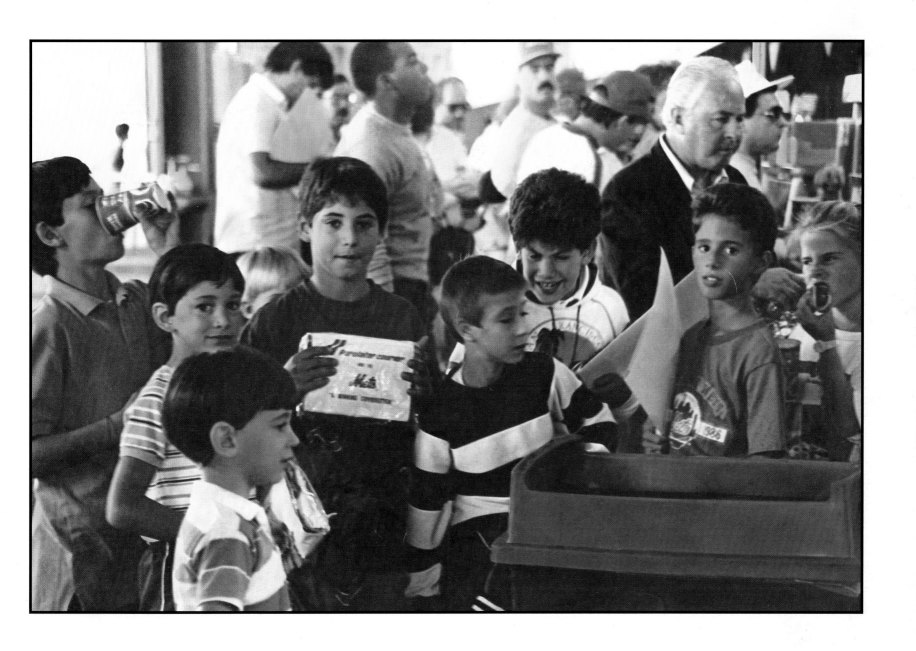

The snack bar is busy.

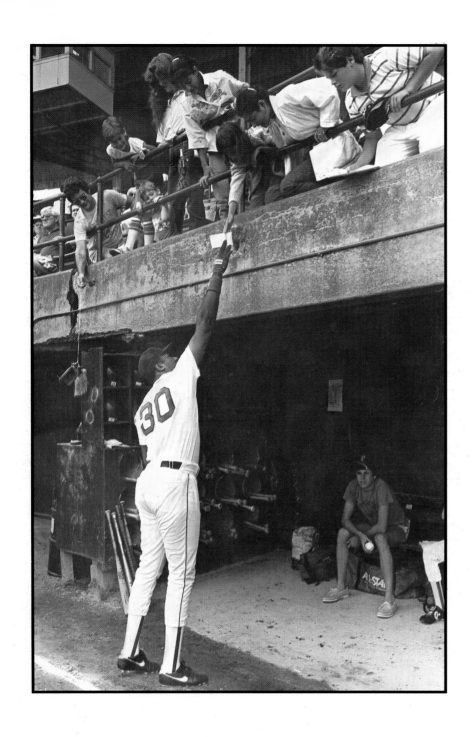

Some get an autograph

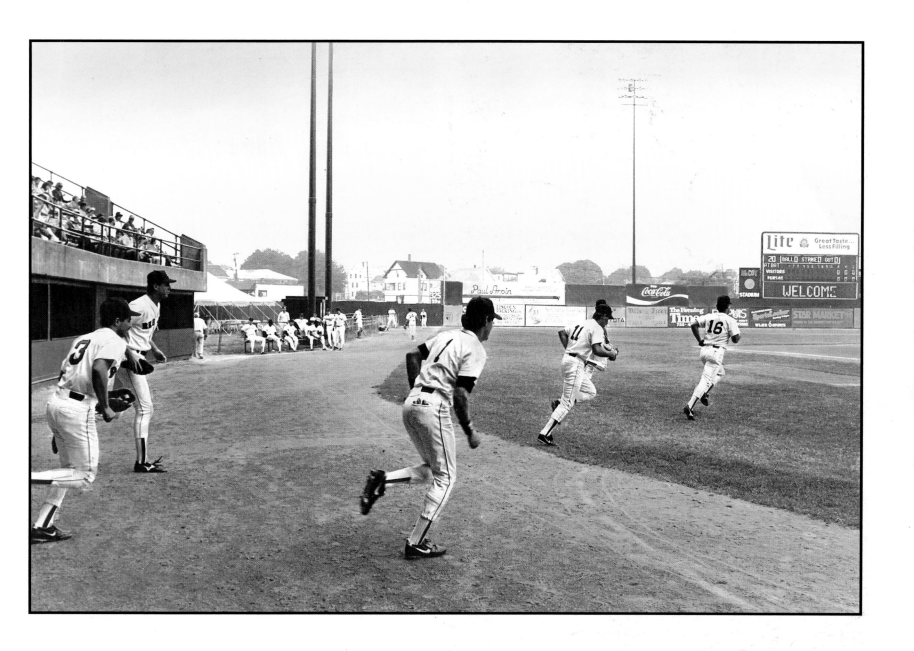

before the players take the field.

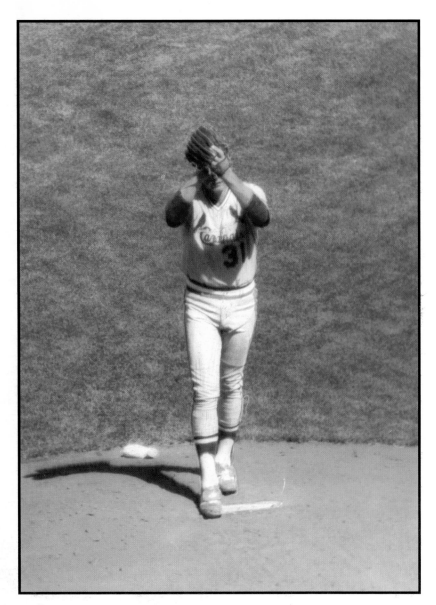
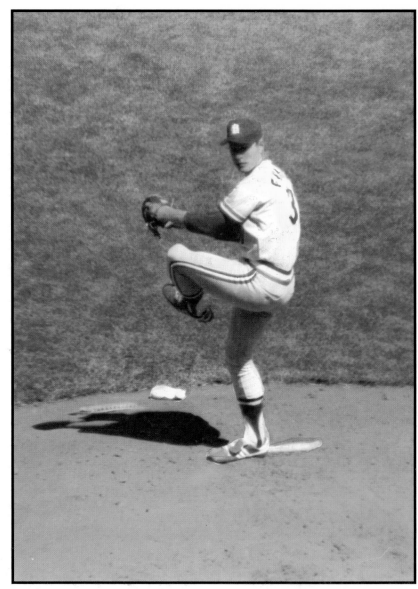

The pitcher winds up and throws the ball.

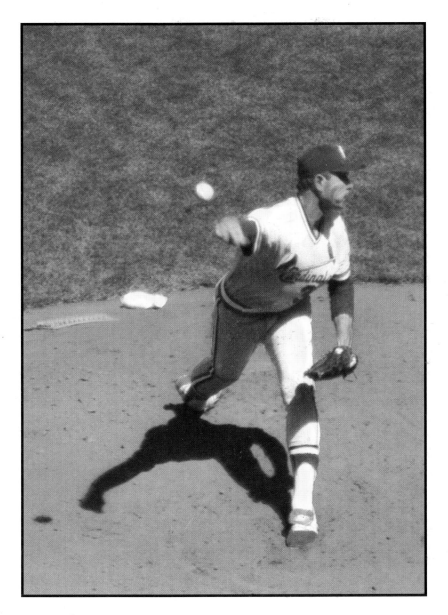
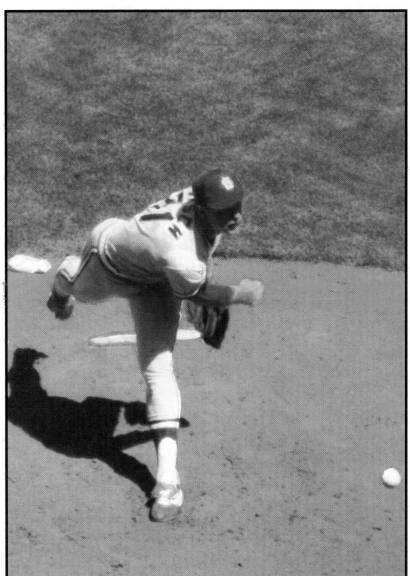

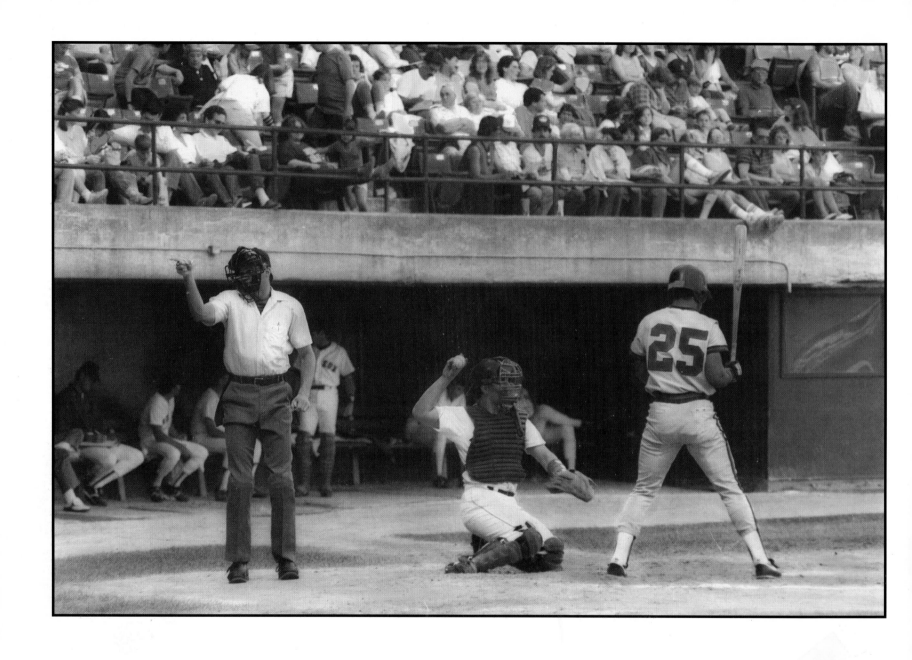

The umpire calls a strike.

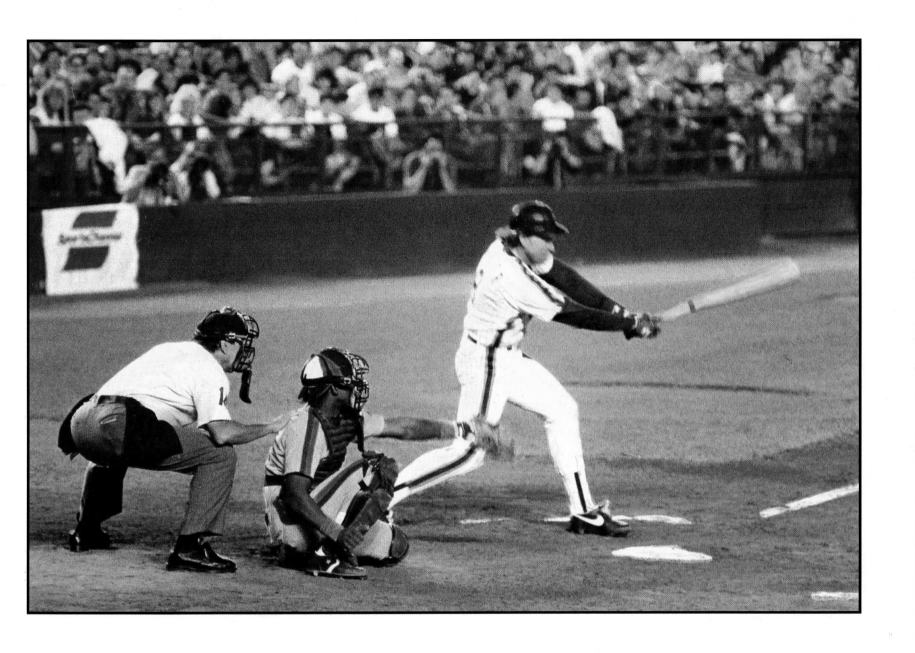

There's a hit.

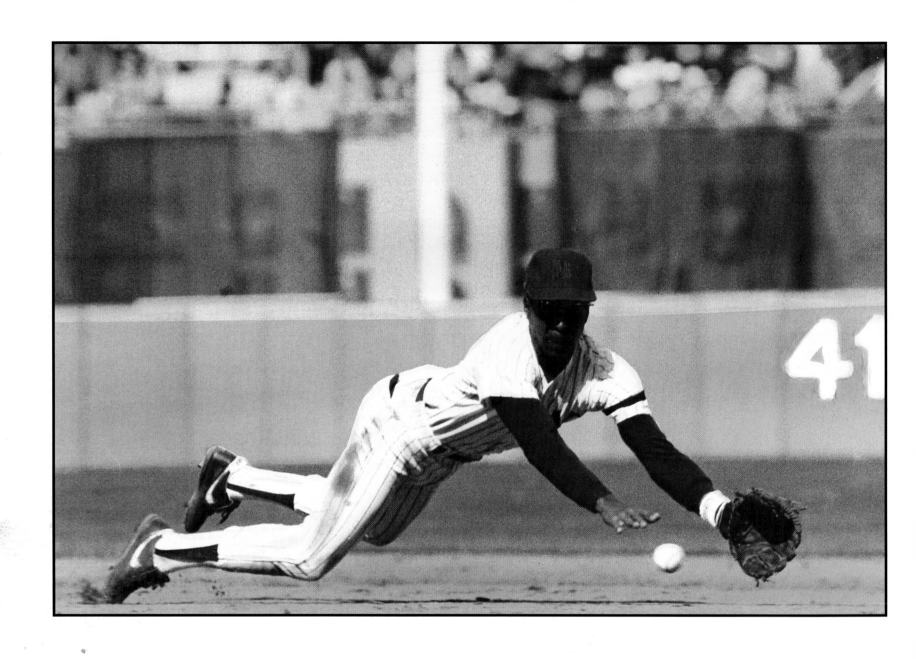

A spectacular catch.

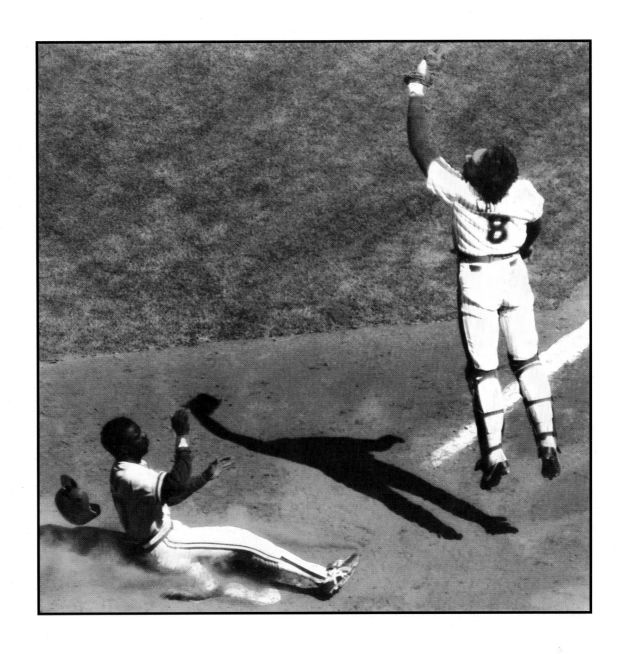

A runner safe at home.

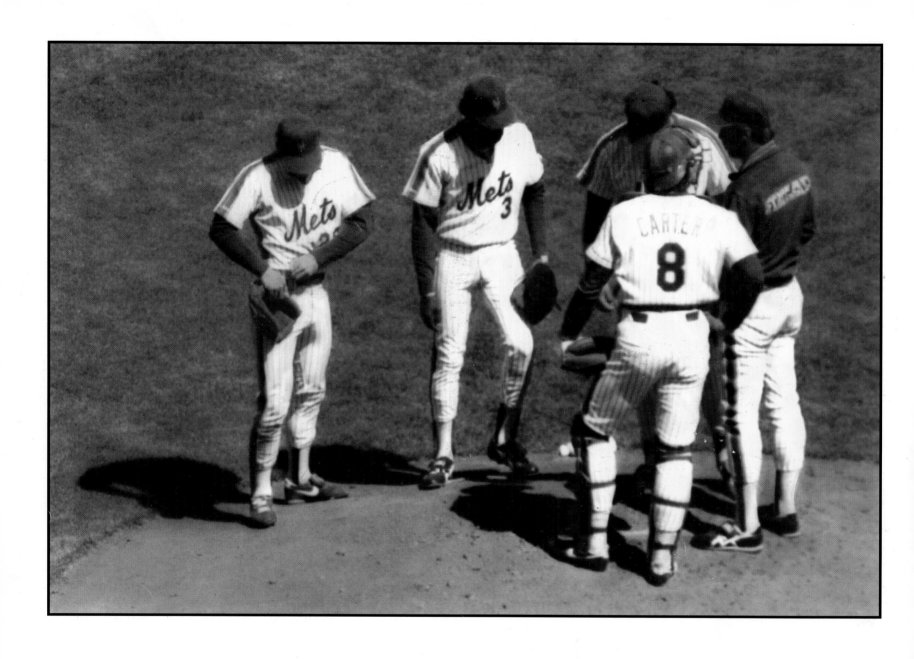

A conference at the pitcher's mound.

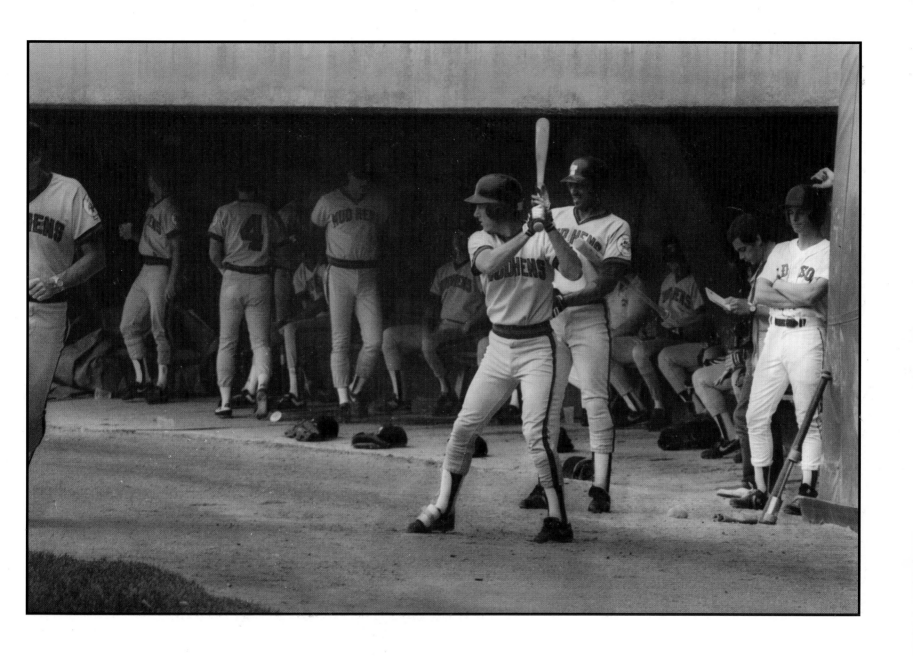

The players wait their turn at bat.

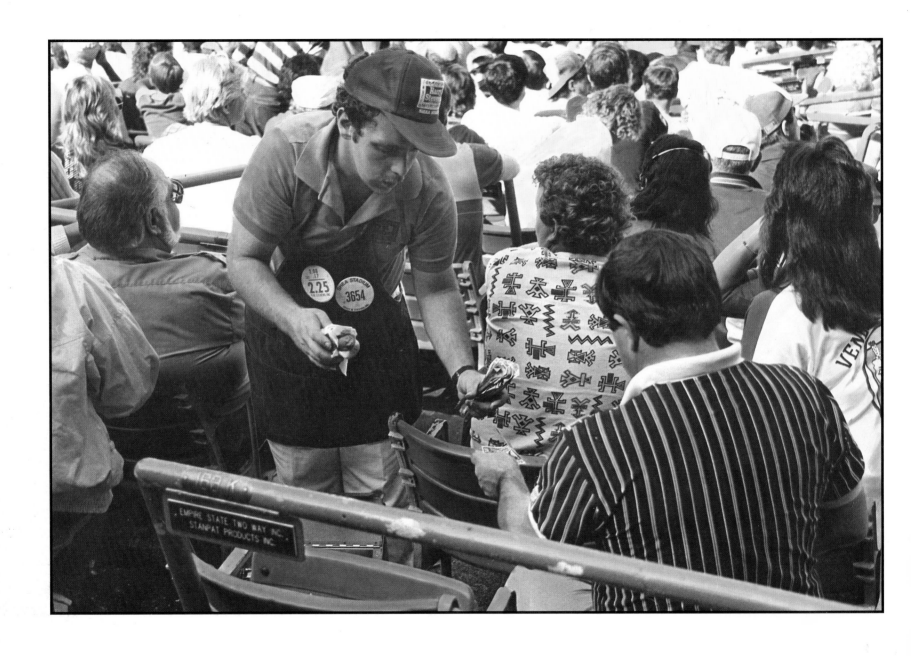

There are hot dogs and soft drinks...

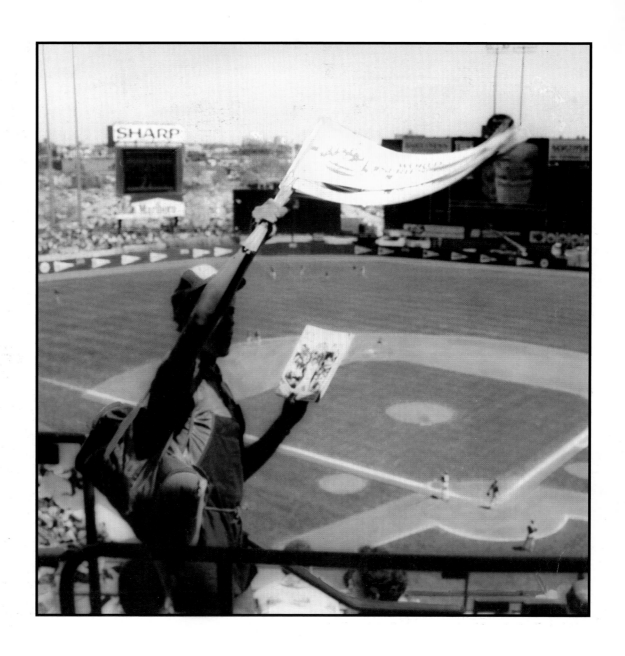

and souvenirs to buy.

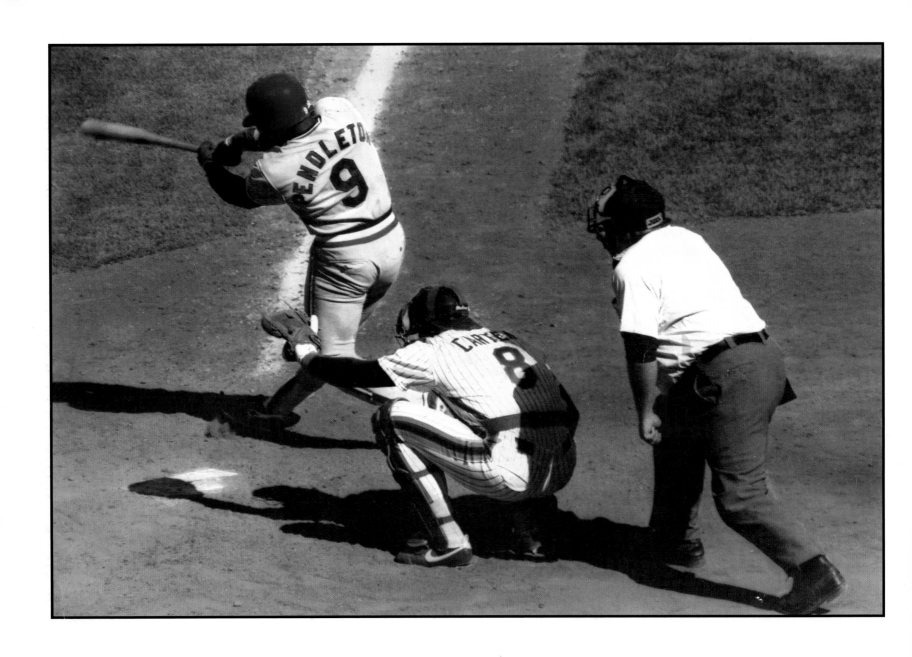

Another swing,

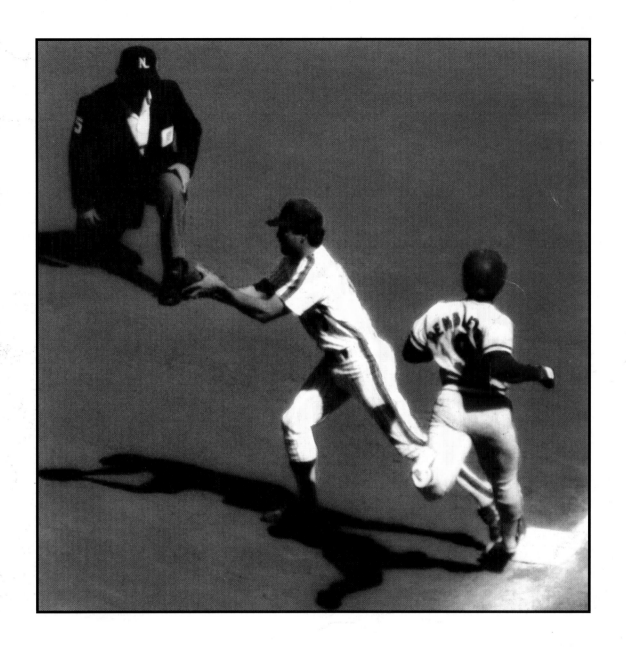

another out.

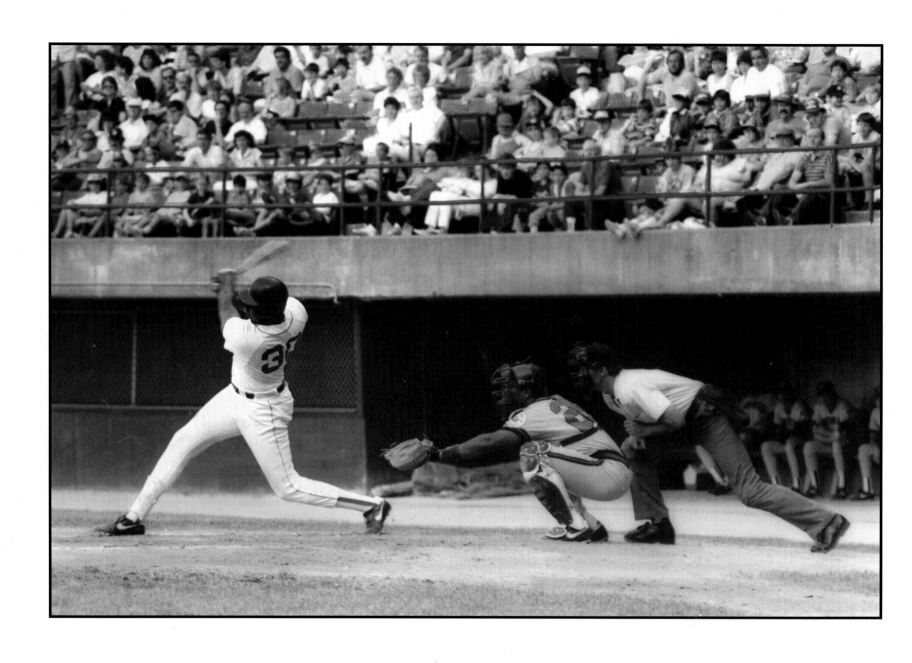

One last hit, a long home run.

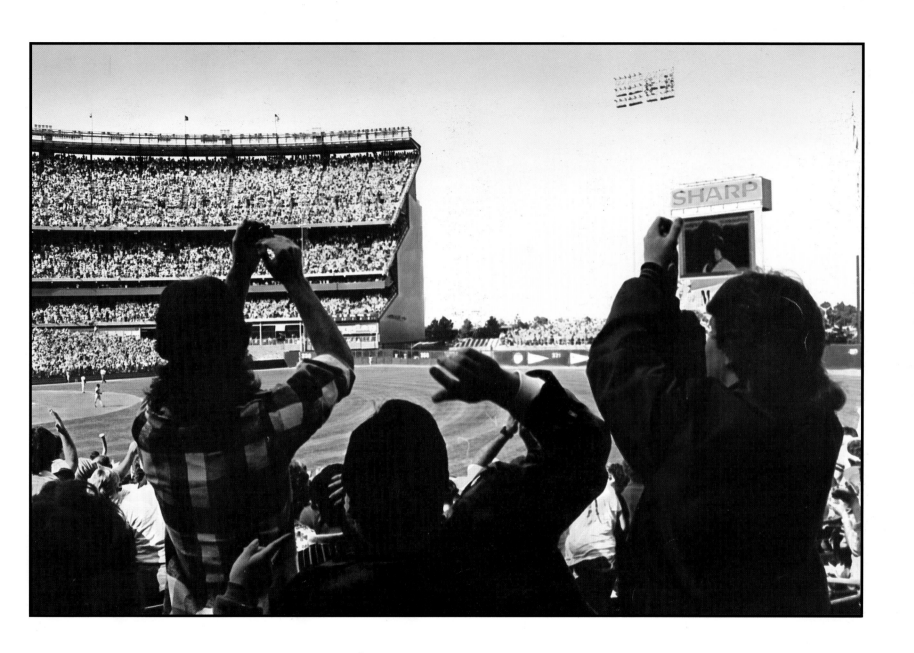

The crowd is on its feet.

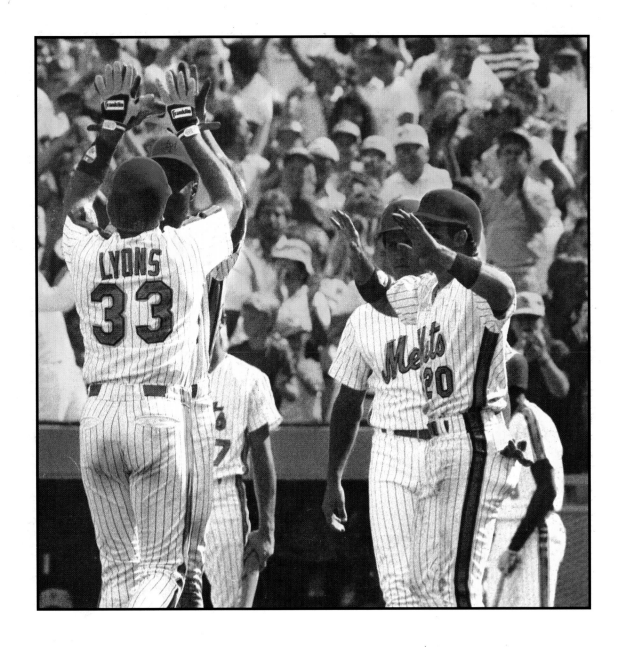

The winners are elated.

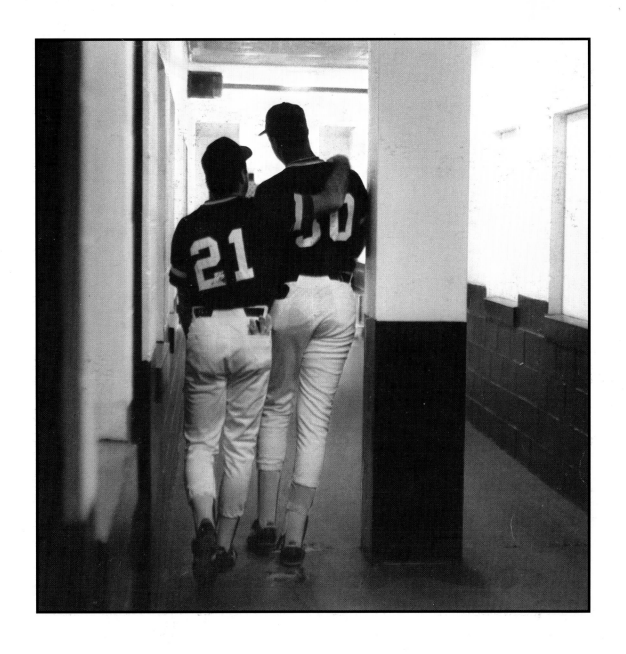

The losers console one another.

It's all over till next time.